Drawing

Sue Stocks

For Tom and Kati

With photographs by Chris Fairclough

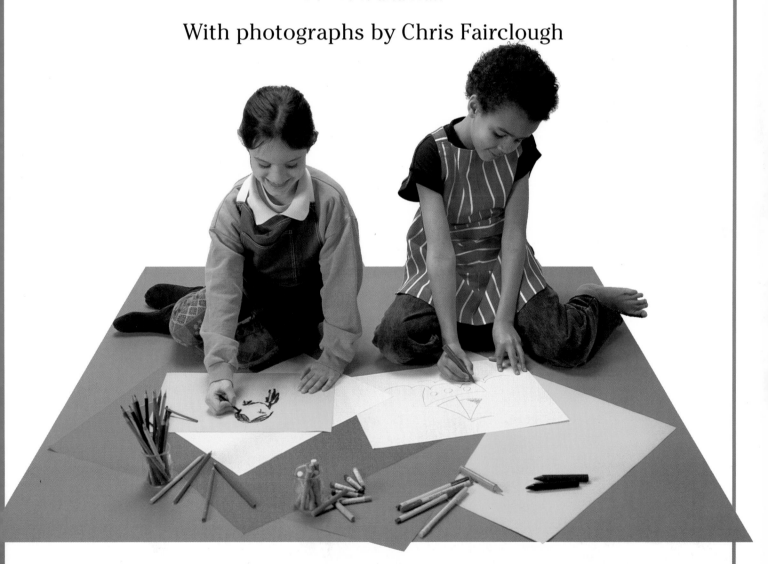

Wayland

FIRST ARTS & CRAFTS

This series of books aims to introduce children to as wide a range of media approaches, techniques and equipment as possible, and to extend these experiences into ideas for further development. The National Curriculum proposals for art at Key Stage One place particular emphasis on the appreciation of art in a variety of styles from different cultures and times throughout history. The series broadly covers the National Curriculum attainment targets 1) Investigating and Making and 2) Knowledge and Understanding, but recognizes that circumstances and facilities can vary hugely. Children should experiment with, and add to, all the ideas in these books, working from imagination and observation. They should also work with others, where possible, in groups and as a class. You will find suggestions for and comments about each section of work in the Notes for parents/teachers at the end of the book. They are by no means prescriptive and can be added to and adapted. Unless a particular type of paint or glue is specified, any type can be used. Aprons and old newspapers provide protection for clothes and surfaces when working with pastels, charcoal and wax resist. Above all, the most important thing is that children enjoy art in every sense of the word. Have fun!

Titles in this series

Collage, Drawing, Masks, Models, Painting, Printing, Puppets, Toys and Games

First published in 1994
by Wayland (Publishers) Ltd, 61 Western Road, Hove
East Sussex BN3 1JD, England
© Copyright 1994 Wayland (Publishers) Ltd
Series planned and produced by The Square Book Company

British Library Cataloguing in Publication Data
Stocks, Sue
Drawing - (First Arts & Crafts Series)
741.2
ISBN 0 7502 1012 5

Photographs by Chris Fairclough
Designed by Howland ■ Northover
Edited by Katrina Maitland Smith
Printed and bound in Italy by G. Canale & C.S.p.A., Turin

Contents

Drawing materials

There are lots of different ways of drawing and many things you can draw with. Thousands of years ago, cave people used their fingers, and sticks dipped into mud, to draw pictures on to the walls of their caves. Some peoples in different countries use their fingers to draw bright patterns on their faces and bodies. Using a stick, you can even draw a picture in wet sand. In this book, we are going to try drawing with different things.

You will need:

A variety of drawing materials, including different pencils such as HB, B, 2B, 3B (the more the better), coloured pencils, water-soluble pencils, charcoal sticks, wax crayons, pastels, coloured felt-tipped pens, a fine-line black fibre-tip pen

Paper

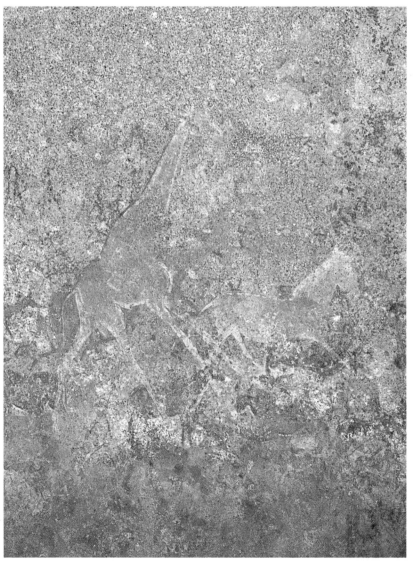

Cave paintings by the San Peoples, Matopos National Park, Zimbabwe.

Take a large sheet of paper and a pencil. Start to draw a line across the paper. Turn left. Don't take your pencil off the paper. Keep going. Now turn right. Take your pencil for a walk across the paper in different directions. Cross over some of the lines you have already made. See the different shapes appear.

• Keep going until your paper is covered with lines.

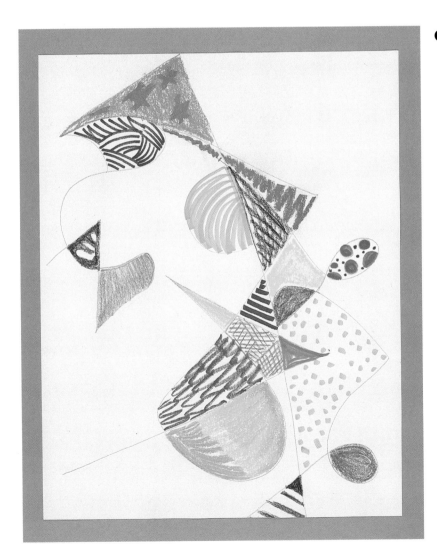

• Now fill in the shapes you have made with different colours and black and white. Use all the pens, pencils, crayons and the other drawing materials you have collected. Make dots in some shapes. Criss-cross your colour in other shapes.

When you have filled in all the shapes, look at the pattern they make.

Pencil patterns

In this picture of a horse and its rider, the artist has used lots of flowing lines.

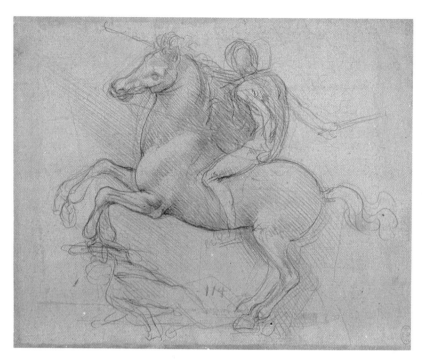

Drawing for the Sforza Monument by Leonardo da Vinci (1452-1519). Crayon.

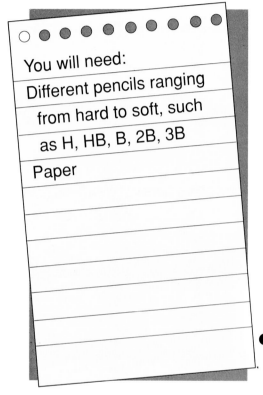

You will need:

Different pencils ranging from hard to soft, such as H, HB, B, 2B, 3B

Paper

Try drawing with your different pencils.

- Make a few lines with each pencil on a big sheet of paper. Draw large circles. Make shapes. Use your whole arm as you draw.

Some of your lines will be pale. Some will be dark. Hard pencils make pale lines; soft pencils make dark ones. How can you tell the difference between your pencils? Look at the letters and numbers on your pencils. Hard pencils have the letter 'H' on them. Soft pencils have the letter 'B'.

- Take two big sheets of paper. Tear some pieces out of one of them so that you leave lots of different-shaped holes. Lay this sheet on top of the other.
- Take a pencil and fill in one of the shapes. Do it very lightly.
- Fill in another shape with the same pencil. This time, press harder. Are the lines darker?
- Take another pencil and fill in a different shape with straight lines. Draw them close together and all going the same way. This is called hatching.
- Change pencils again. Fill another shape with lines. Then go over the top with more lines that cross over the others. This is called cross-hatching.
- Take another pencil. Use the side of the lead instead of the tip to fill in another shape.

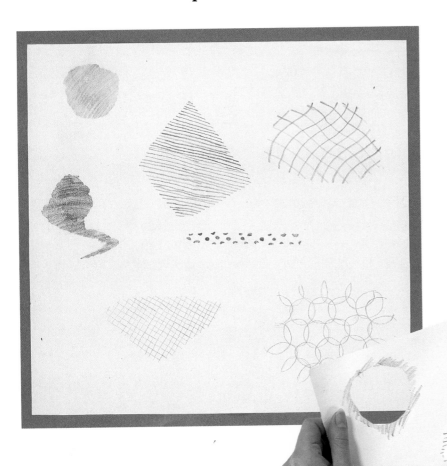

Use all your pencils in different ways to fill in all the shapes. Make wavy lines and dots. When you have finished, lift off the top sheet and see your pattern.

Leaves

You will need:

A variety of hard and soft
 pencils

Paper

A collection of leaves

The leaves on your
paper will be light
and dark.

Look at the patterns and shapes of the leaves you have collected. Put the leaves in a row and look at them very closely. Now put the leaves in order ranging from light to dark, so that the lightest leaf comes first and the darkest leaf comes last.

- Choose three leaves and three pencils (an H, a B and a 2B).
- Put the leaves under a sheet of paper.
- Take one of your pencils and gently rub over the top of one of the leaves. Try to use the side of the lead, not the top. See the leaf appear.
- Rub over the top of another leaf with a different pencil.
- Do the same with your last leaf and pencil.

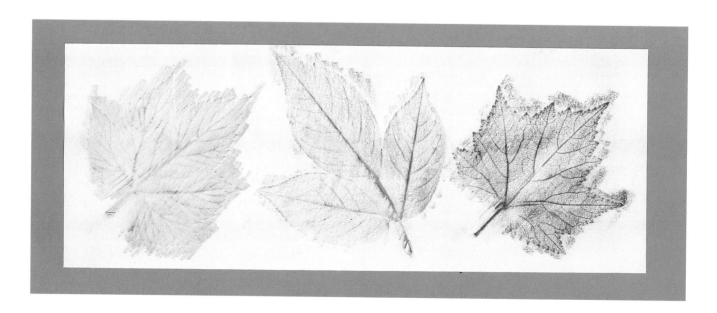

Look at this picture of leaves floating on a pond. What else can you see in the water?

Now you are going to draw your leaves. Put them close together in front of you. Look carefully at the shapes. What else can you see? Look at the lines and patterns on the leaves.

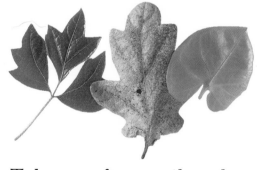

Take a soft pencil and a sheet of paper. Choose a leaf to draw. Draw the outline of the leaf first.
Now try to draw the lines on the leaf. Can you fill it in to show the light and dark areas as well? Do it very gently.

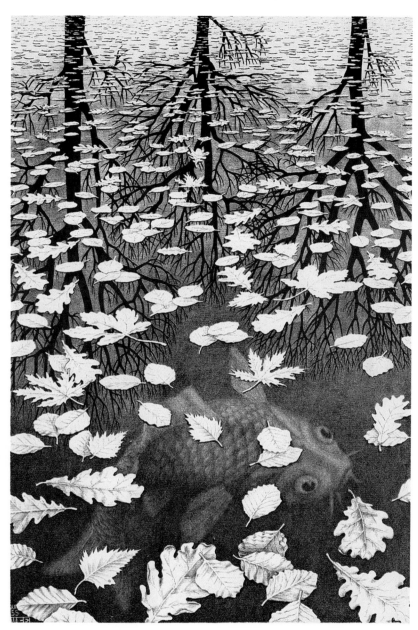

Three Worlds - 1955 by M. C. Escher (1898-1970). Print.

Try drawing all your leaves like this. When you have finished, cut them out and stick them on to coloured paper.

Pastel bubbles

Try drawing with your coloured pastels on different coloured papers.

- Take a sheet of coloured paper. Try out all your coloured pastels on the paper.
- Take another colour of paper and use your pastels again. Make some big shapes and lines.
- Choose a light coloured pastel and fill in a shape.
- Now take a darker colour and go over half of your first colour. Don't press too hard. See how the colours mix.
- Fill in some more shapes with other pastel colours.

Look at this pastel picture. See how the artist has put different colours on top of each other. You can do the same in your pictures.

Ask an adult to help you scrape some chalk from the side of a pastel with a knife or the blade of the scissors.
Cut out a small circle from a sheet of paper. Put this sheet over another one.
Dip the cotton wool into the chalk powder and rub it into the circle you have cut out. Add more powder to one half of your circle. Does it look different?

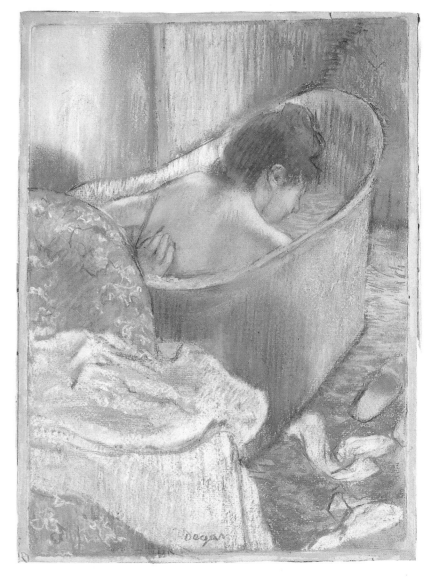

Le Bain by Edgar Degas (1834-1917). Pastel.

Lift off the top sheet of paper and see the shape underneath. Make lots of different-coloured circles like bubbles.

Next time, cut different shapes from the top sheet of paper. Make a sheet of patterns.

Masks and head-dresses

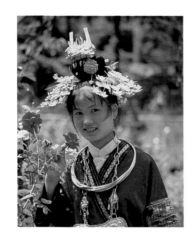

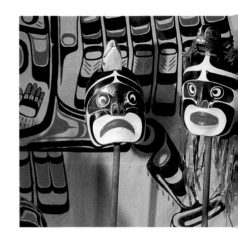

Look at these photographs. They are of masks and head-dresses from different countries. Some are from festivals. Have you ever been to one?

Tribal masks are sometimes made for special dances. Others are made to frighten enemies away. You are going to draw a mask. What will yours be like?

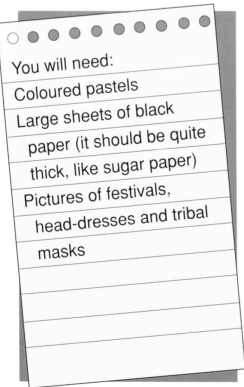

You will need:

Coloured pastels

Large sheets of black paper (it should be quite thick, like sugar paper)

Pictures of festivals, head-dresses and tribal masks

- Choose a mask or a head-dress from these photographs or from your own pictures.
- Try to draw the mask or head-dress with your pastels. Start at the top of the paper and work down.
- Keep looking at the picture you have chosen as you draw. Use bright colours.

When you have finished your drawing, put it on the wall.

Now you are going to make up your own mask. Will it be smiling or fierce? Look in a mirror and smile. See the shape of your mouth. Now frown and look again. Look at your eyes and eyebrows too.

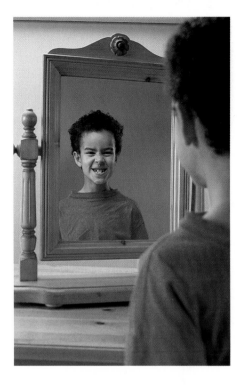

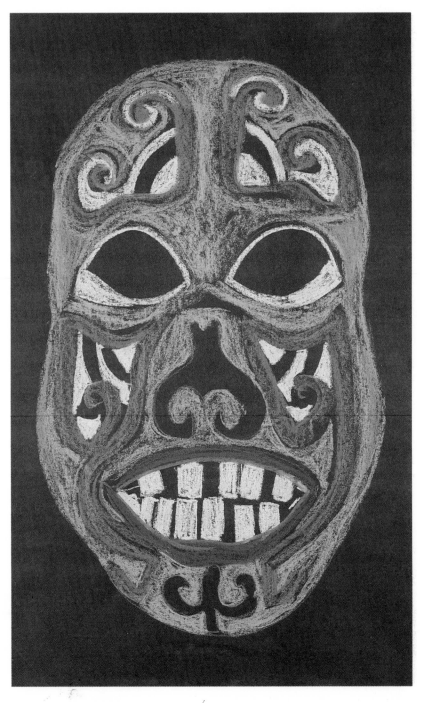

- Use your pastels to draw the outline of your mask. Make it big.
- Draw in the nose, eyes and mouth.
- Decorate your mask with lots of colours. Try to mix them sometimes by putting one colour over another.

Next time, draw a different mask. Hang them together on the wall. Are they fierce or friendly?

Birthday party

You will need:

Coloured pencils

Paper

A collection of things with interesting, bumpy textures, such as sandpaper, bubble-wrap, plastic and string

Try out your coloured pencils on a sheet of paper. Make patches of different colours next to each other. Which colour do you like best? What is it called?

Coloured pencils are different from pastels. Try drawing and shading with your coloured pencils. Try mixing colours by putting one on top of another, just as you did with your pastels. Do they look the same when you mix them?

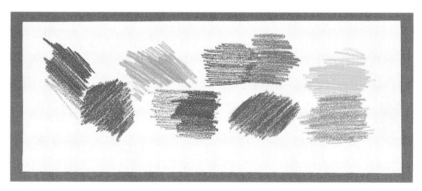

Now make some drawings with the things you collected.

● Put some sandpaper under a piece of drawing paper.
● Rub a coloured pencil gently over the top of the paper where the sandpaper is. Use the side of the lead and try to rub smoothly - don't scribble! See the marks that appear.

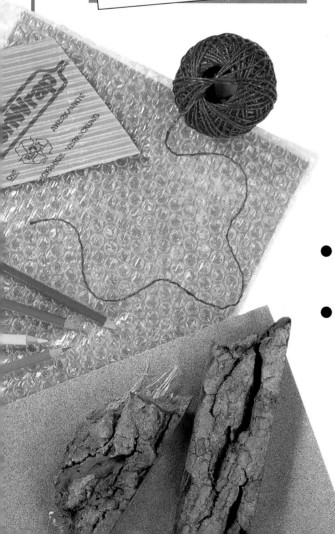

Make some more rubbings of the sandpaper with other colours. Now put a piece of string under the paper and make another rubbing. Do the same with all the things you collected.

Artists sometimes make pictures like this. It is called frottage.

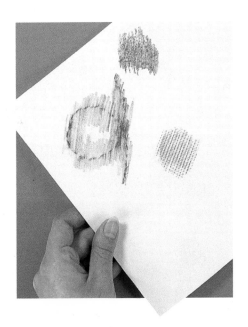

Now you are going to draw a picture. Draw a birthday party. It could be your birthday party or one you have been to. You could draw the table with the cake and all the food on it. You could draw the presents wrapped up in colourful papers. What else could you draw?

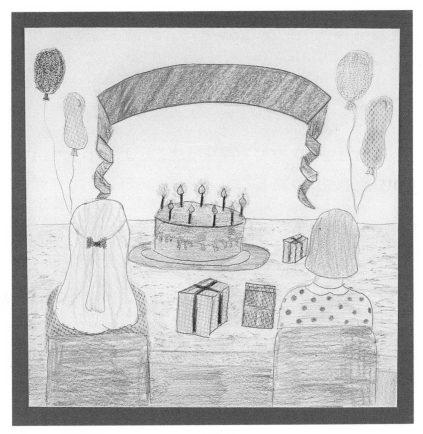

- Draw your picture on a big sheet of paper. Keep it simple.
- Choose the colours you are going to use. Think about the things you could put under your paper to make interesting marks in your picture. You could use string for hair, or sandpaper for the paper on a present.

Family and friends

Look at this picture. It is by a famous artist and sculptor called Henry Moore. Look at the shapes of the people.

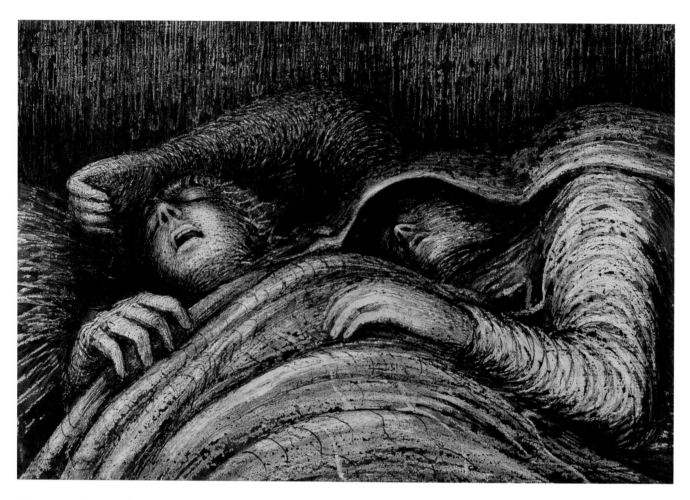

Pink and Green Sleepers 1941 by Henry Moore (1898-1986). Pen and ink, chalk, crayon and wash.

You are going to draw a picture of your family or friends. Try drawing with charcoal first.

Draw big circles and ovals with your charcoal sticks and pencils on a large sheet of paper. Use your whole arm when you draw. Do you like using the sticks or the pencils best?

Draw sausage shapes. Join them together to make people shapes, using a circle for the head. Try not to rest your arm on your drawing or you will make a mess of the charcoal.

You will need:
Charcoal sticks
Charcoal pencils
Large sheets of paper

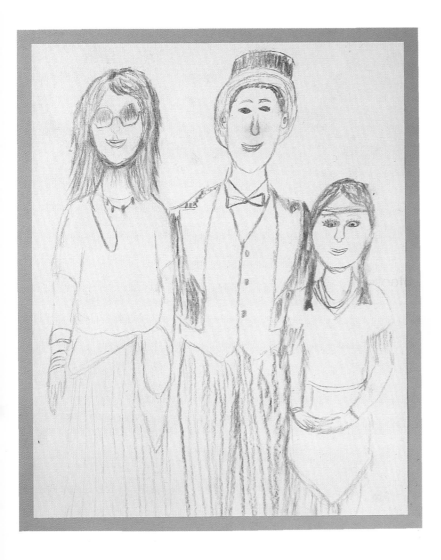

When you have practised drawing with charcoal, draw some of your friends or family. Choose two or three of them. Ask them to stand together in front of you. Are they all the same size? Look at the shapes of their bodies. Start to draw. Keep looking at the people as you draw. Make your drawing very big.

Tropical birds

This is another drawing by the artist and sculptor who drew the people on page 16. He used wax crayons to make this picture.

Another book in this series, called *First Arts & Crafts: Painting*, shows you how to make pictures with wax resist.

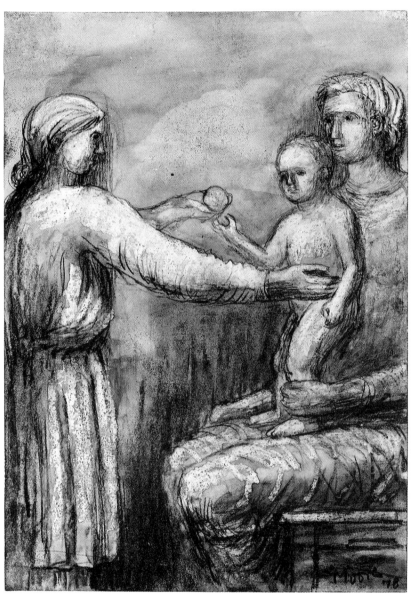

Mother and Child Scene 1978 by Henry Moore. Pencil, charcoal, chalk, wax crayon and wash.

You will need:

Wax crayons

Black paint

Water jar

Wide paintbrush

Palette or old plastic plate

Washing-up liquid

Paper and stiff card

Nail or small screwdriver

Pictures of tropical birds

A collection of feathers

- Draw a picture with wax crayons.
- Mix some thin paint and brush it lightly over the top. See your picture appear.

Now you are going to use wax crayons in a different way.

Take a small piece of stiff card. Colour over the card with wax crayons. Use lots of colours and build up a thick layer of wax. Put another colourful layer of wax on top.
Mix some black paint. Add a squeeze of washing-up liquid and mix it in.
Brush the black paint thickly over the card.
When the paint is dry, use a nail or screwdriver to scratch patterns through the black. Look at the colours appearing underneath. This way of drawing is called sgraffito.

Look at these photographs of colourful birds.

Use sgraffito to make your own bright picture of a bird on a big sheet of card. Look also at your own pictures of birds and at the lines and patterns on the feathers you have collected. Will the feathers on your bird be like these? Make lots of different marks through the black paint to make your bird interesting.

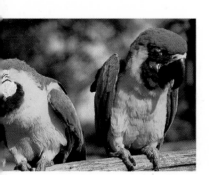
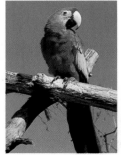

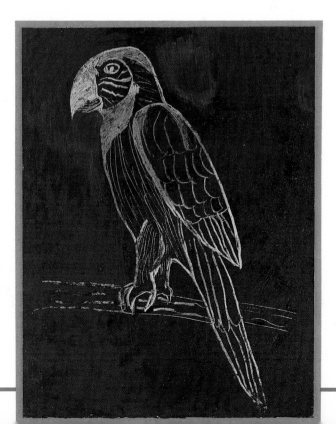

Fruit and vegetables

In *First Arts & Crafts: Painting*, we looked at pictures made out of dots. This is called pointillism. You can use felt-tipped pens to make pictures out of dots. You can use them to draw in a number of different ways.

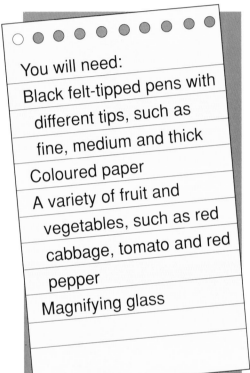

You will need:

Black felt-tipped pens with different tips, such as fine, medium and thick

Coloured paper

A variety of fruit and vegetables, such as red cabbage, tomato and red pepper

Magnifying glass

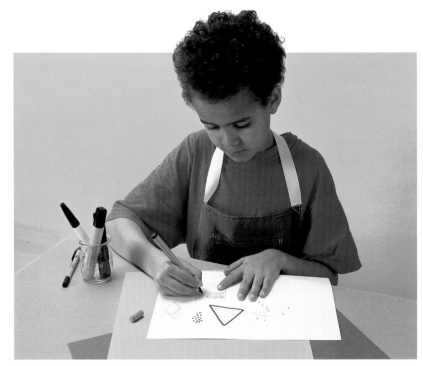

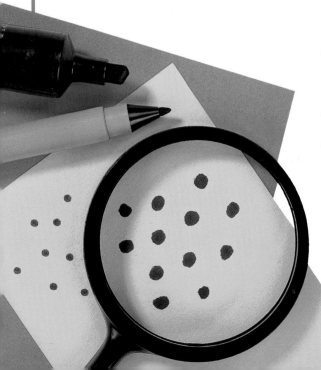

- Make some dots with the different pens on a sheet of paper. Keep some of the dots close together. Spread others out.
- Draw some small shapes and fill them with dots.
- Now draw some lines close together.
- Draw more lines and cross over them with other lines. You have done this before with pencil. Can you remember what it is called? Does it look different this time?

Now look at this piece of red cabbage. Can you see the lovely patterns and the wavy lines?

Choose a thick pen and a large sheet of coloured paper. Look at the light and dark parts of the cabbage. Look at them again through a magnifying glass. Try to draw the patterns that you see. Just use dots.

Now draw the cabbage again. Try using cross-hatching this time, or just make thick and thin lines with your pens. Keep looking at the pattern of the cabbage.

Ask an adult to help you cut some other vegetables and fruit in half. Draw the patterns you see.

Next time, make some drawings like this with different-coloured pens.

Water-colour pencils

You can use water-soluble colour pencils in different ways.

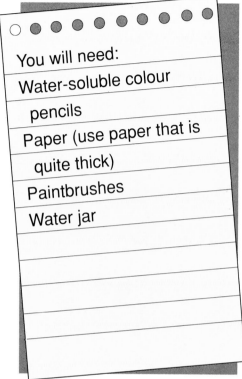

You will need:

Water-soluble colour
 pencils
Paper (use paper that is
 quite thick)
Paintbrushes
Water jar

- Take some white paper and practise drawing with them just like ordinary colour pencils.
- Now draw the first letters of your name in different colours. Dip a paintbrush into some water and brush it over the letters. Watch the colours spreading.
- Draw the letters again, but this time dip the tips of your pencils in the water first.
- Now, wet some paper with a brush dipped in water. Draw your letters on to the damp paper.

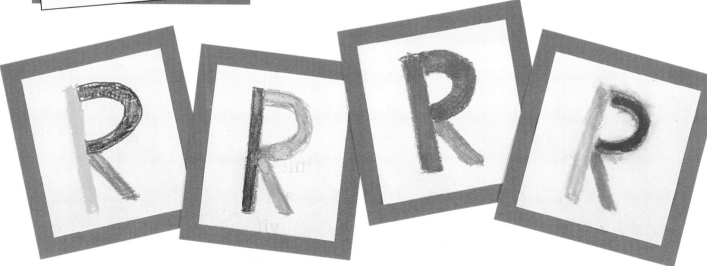

You have tried four ways of drawing with the pencils. How are they different? Remember that you can mix and hatch them too. Use these pencils to make a picture about a view through a window. You may have done this before with other books in this series.

Look at this picture. Where do you think it might be? Your window picture could be about a holiday or a holiday view.

Think about the different shapes of windows you see. Will your picture be looking into a room or out of it? What might you see? Draw your window picture using one of the ways you have tried with your colour pencils.

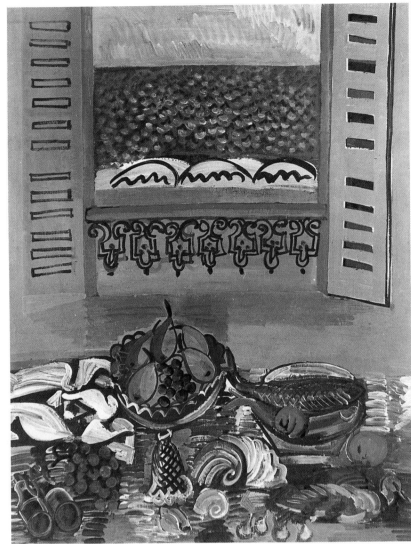

Still Life with Fish and Fruit by Raoul Dufy (1877-1953). Oil on linen cloth.

Next time, make a different window picture and use another way of drawing with these pencils. Put your two windows together on the wall.

23

Impressing

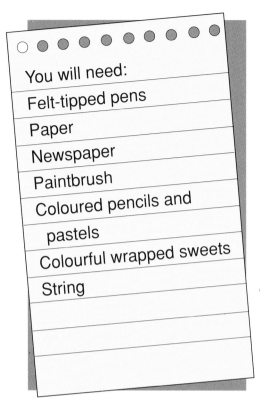

You will need:

Felt-tipped pens

Paper

Newspaper

Paintbrush

Coloured pencils and
 pastels

Colourful wrapped sweets

String

Practise drawing with your felt-tipped pens. Use some of the different ways you have learnt in this book.

- Now lay a sheet of drawing paper over some folded newspaper.
- Use the end of the paintbrush handle to draw an invisible picture on to the drawing paper. Press quite hard.
- Colour lightly over your 'drawing' with a felt pen. See the picture appear.

Try this again, using a crayon or pastel instead of the felt pen. This way of drawing is called impressing.

Now colour some paper with a felt pen.
Lay the paper over the folded newspaper
and draw another picture with the
paintbrush handle.
Colour lightly over the top with a darker
crayon or pastel. Does this look very
different from the first picture you did?

Choose some brightly wrapped sweets.
Put one in front of you.
Draw the sweet in the way you have been
practising. Make it big. Draw in any
patterns or creases on the sweet wrapper.
Draw more sweets like this.
Now draw some sweets just using the
felt-tipped pens. Use lots of colours.

When you have finished, cut your sweets
out and string them together.

Portraits

This drawing is a portrait. For a very long time, people have had their portraits painted by famous artists. Sometimes, artists paint pictures of themselves. These are called self-portraits.

Portraits and self-portraits that were painted many years ago tell us about the way the people lived and what their jobs were. Their clothes and pets, as well as objects and things happening in the pictures, all tell us something. Many years ago, there were no cameras to take photographs of people.

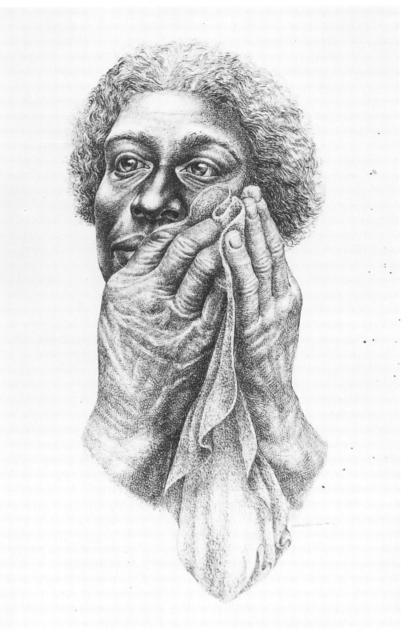

The Mother by Charles White (1918-1979). Ink.

You are going to draw a portrait. Think what will be in the picture. Who will you draw? Will they look happy or serious? Look at the person closely. What colour hair does he or she have? What are the clothes like? What else will you put in the picture with the person - a favourite toy or a family pet? Put in the things that remind you of that person.

Take a large sheet of paper and a pencil, pastel or whatever you like best to draw with. You could use a few different things in the same picture.

You will need:
A variety of the drawing materials you have used in this book
Paper

- Sit in front of the person you are going to draw.
- Draw the person from top to bottom, starting with the head.
- Keep looking at the person as you draw.
- Don't forget the background.

Make a frame for your portrait when it is finished.

Black and white

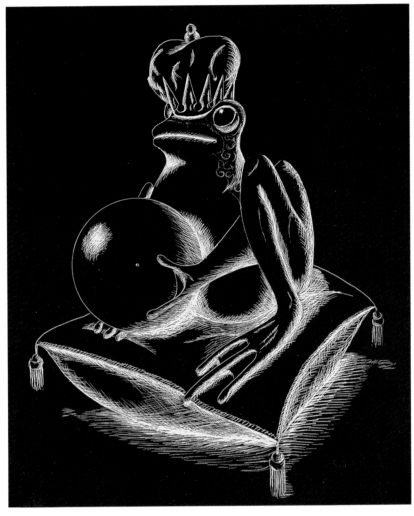

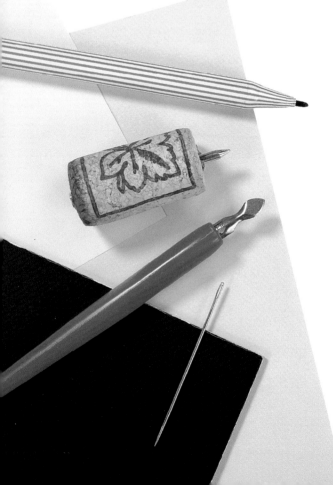

This picture was drawn on scraperboard.

Take a piece of scraperboard and practise making different lines and marks on it with your tool. See the white lines appear as you scrape the black away. Think of all the lines and marks you have tried in this book - dots, lines, crossed lines, zig-zags. Try them all. Think of some more. Try out your own ideas.

Your picture is going to be black and white. Think of a favourite story or poem. Can you draw a picture about something that happens in it? Try to make it interesting. Make lots of marks in the scraperboard to show different textures.

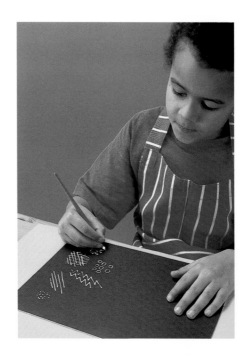

When you have finished, draw another picture of the same scene. This time, draw it on the white paper with a black pen. Try to make it the same as the first picture. Now look at the two together. You have black on white and white on black. Do they look very different?

Put them together on the wall.

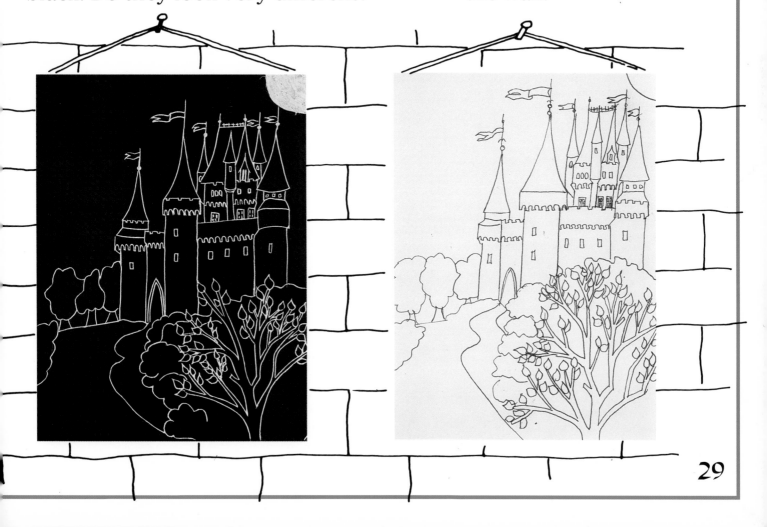

FIRST ARTS & CRAFTS: DRAWING introduces children to a wide range of drawing media and some of their associated techniques. Each section offers scope for further work in whichever way the teacher or parent chooses to develop it. Try to encourage children to practice and experiment fully with each new medium as it is introduced. Let them discover its possibilities and limitations and get them to mix the media in a variety of ways as they become more familiar with the materials. Throughout this series, it will be evident that there are overlaps where the same or similar techniques and media appear in more than one book (wax resist and rubbings, for example). This is deliberate since it is hoped that children will begin to see this link: it is rare for a medium to be used in isolation and with only one approach. Drawing forms a sound foundation which leads naturally into other areas of technique, but purely intuitive responses are also to be encouraged. Collect examples of artists' preparatory sketches for paintings, sculptures and printmaking, and display them with the final works. Examples include Auguste Rodin's sculptures, Michelangelo's Sistine Chapel paintings and George Stubbs' animal studies. When children begin to draw, encourage them to work to a large scale where appropriate. Get them to use their arms, not just their hands, to produce bold, loose examples of work. Foster the need to observe. Encourage children to look closely at what is being drawn, and to keep looking back at it, examining outline shape, detail, tone, surface texture and so on. Initiate the building up of a vocabulary for art, such as 'hatching', 'tone' and 'colour wash', so that the children become familiar with the terms.

Drawing materials 4 - 5
Children could also try using white pencil on black paper. Get them to use just wax crayons, pastels, soft coloured pencils and perhaps paint to fill in. Make coloured frames for these and hang them alongside the experiments on white paper given black frames. Encourage comparison and discussion.

Pencil patterns 6 - 7
Collect examples of different pencil drawings by artists such as Michelangelo, Leonardo da Vinci, John Constable, Henri Matisse, Picasso and David Hockney. Discuss them. Let children discover the properties of hard and soft pencils. This exercise uses a form of template. See if the children make a link with this in the section on pastel bubbles. They can use this torn template for further work: pencil some lines through the template, move the template approximately halfway across the pencil work and repeat the exercise. This will create a form of overlaying. Use it with other media, too. Another exercise for children is to tear a small piece of paper into an irregular shape, hold it in place on top of another sheet of paper with one hand, then pencil back and forth across both pieces of paper before removing the top piece. Also, children can try drawing the same object using a 2H and then a 2B pencil. They should compare the results.

Leaves 8 - 9
Show examples of pencil drawings of plants. Examine the collected leaves and encourage discussion about shape, detail and symmetry. Turn some over. Use leaves both ways up for rubbings. Get the children to create pale examples on A4 sheets of paper. They could write a poem about spring or autumn, then write it over the top of the leaf rubbings. Encourage them to use the leaves to produce different results drawn from other books in this series: draw leaves, paint them, make rubbings and use leaves to print with. Study the Escher picture and ask the children to tell a story about it. Older children could move on to work on reflections. Outside, look at puddles, chrome handlebars and hub-caps, car bonnets, windows, sunglasses and so on. Indoors, look at such things as spoons, mirrors, kettles and taps.

Pastel bubbles 10 - 11
Collect other examples of pastel and chalk work by Degas. Draw the children's attention to the way he has overlaid the colours. Get them to try hatching and cross-hatching using different textured papers and colours. Compare Degas' work with other chalk and pastel work by artists such as Georges Seurat and Toulouse-Lautrec. Introduce children to the work of impressionists and post-impressionists. Older children could do further work on this theme. When working with the template, refer to work in the section on Pencil patterns in this book to establish links. Further extension work could involve the use of oil pastels. Use and compare these with standard pastels, then ordinary coloured chalk. Oil pastels could also be used for wax resist pictures (see pages 18-19).

Masks and head-dresses 12 - 13
Masks from different cultures could be compared and developed into a project. Japanese, Venetian, Aztec and ancient tribal masks will all provide rich and contrasting examples. Further work could include masks used for festivals, theatre and circuses. Extend the work to include making 3-D examples in paper, papier mâché, clay and so on. Whilst not strictly masks, pumpkin heads lit from within simply demonstrate facial expression. Older children could use Mod-Roc (bandages impregnated with plaster of Paris) to make heads based on chicken-wire frames. When dry, these heads set hard and can be painted and decorated. The children could make up a play based on the masks they have made.

Birthday party 14 - 15
Look at the coloured pencil work of David Hockney. Encourage children to experiment with coloured pencils; hatching and cross-hatching, making short spiky lines, changing colour, filling in some parts with dots, changing colour again, pencilling

over some of the pattern they are making with loose, open lines, and over another part with lines close together. Discuss how these results are different from the work they have done with pencil and pastel. Frottage can be used in various ways. Do the children see any link between this exercise and the leaf rubbings?

Family and friends 16 - 17
Collect pictures of family groups by Henry Moore. Examples include *Two Women Bathing a Child* of 1948, *Family Group* of 1944 and *Woman Seated Reading (The Artist's Sister)*, 1925. Few, if any, are in charcoal alone; Moore also used inks, pencils and wax in many of his drawings. Examine the overall effects. Look at the roundness and strength of his figures. Compare these to his other more angular works, such as *Six Studies for Family Group* of 1948. Also introduce Moore's family group sculptures. Introduce the charcoal work of Picasso, Degas, Van Gogh and Matisse. Encourage children to work to a large scale. Join large sheets of sugar paper together. In class, mount a whole wall of drawings of everyone in the class.

Tropical birds 18 - 19
Study the *Shelter Drawings* by Henry Moore, which provide a rich source of ideas for further work. In addition to other art work, there are sociological and historical cross-curricular themes to be followed up. Examining why people were sheltering in the Underground could also produce interesting work; creative writing and drama have strong links here. Look at other examples of Moore's work using wax resist, including *Miner at Work* and *At the Coalface*, both of 1942. When working with wax crayons, let the children use them blunt and sharpened, and compare them to oil pastels. When working on sgraffito, children could try the tip and side of a spoon to make wider lines and marks.

Fruit and vegetables 20 - 21
This work links with pointillism in *First Arts & Crafts: Painting* and with felt-tip pen work in this book. Encourage the children to compare the results. Get them to experiment with pointillism, hatching, cross-hatching, etc., on small squares of paper. Join these together on one large background sheet. Enlarge further examples on a photocopier and discuss the results. Refer to Georges Seurat's pointillist work. Moving on to further pen and ink work, look at examples by Leonardo da Vinci, Samuel Palmer, Rembrandt, Giovanni Battista Piranesi and Arthur Rackham. Ink can also be used with a brush. Look at the brush and ink work of Japanese artists. When drawing the red cabbage, older children can make a small rectangular frame of card or paper to hold in front of an interesting part of the vegetable so that they draw only the part seen through the frame. They can then enlarge it with big pens or make it very small and try to create what is seen using the pointillist technique.

Water-colour pencils 22 - 23
The windows theme recurs throughout this series, and children should be encouraged to compare the results of work produced using all the different approaches and media. Collect diverse examples of views through windows both from inside and outside, and include work by artists as well as photographs. Ensure you have some water-colour paintings to show. When planning the exercise, explore all the possibilities with the children. Often the simplest and most obvious ideas produce the best results, but explore the alternatives first. Is the view from within a building or a mode of transport? Think about window shape and frame, location, historical period, and so on. When using water don't let the paper get too wet. In class, go on to make a big window on a single theme.

Impressing 24 - 25
Include pointillist techniques when experimenting. Children can use big felt pens to create larger areas of multi-coloured dots. Get them to try pens on damp paper. Try to ensure that the pale colours are used first as they will absorb darker colours on their tips if used after. Make pens with different-shaped tips available for experimenting; some are blunt and wedge-shaped as opposed to round. As in previous sections, look at the work of Seurat, Alfred Sisley and other artists who used impressing as a method of working.

Portraits 26 - 27
Again, this is a recurring theme in the series, with endless possibilities. Look at portraits and self-portraits. Examples could include works by Alberto Giacometti, Rembrandt, Matisse, Edvard Munch, Hockney, Gwen John, Hans Holbein the Younger, Lucian Freud and Francis Bacon. Compare these with sculptures and prints. When planning their portraits, children should think about facial expression. An interesting example for discussion could be Munch's *The Scream*. Also think about surroundings and 'clues' about the sitter. The National Portrait Gallery in London has a wealth of examples and offers talks, workshops and guided tours for schoolchildren (telephone: 071 839 3321).

Black and white 28 - 29
Encourage children to experiment with lots of different marks, using a variety of implements to add to the range. A good book with many examples of work in black and white is *Scratchboard for Illustration* by Ruth Lozner. It is also possible to buy white scraperboard to provide a third method of drawing the same picture in black and white for children to compare. In addition, paint white on black paper and vice versa. Take some drawings and paintings in colour and photocopy them. Compare the black and white copies to the originals - does anyone notice a wider tonal range than just black and white? Do the children think some look more effective than in the original colour?

Further information

Glossary

Charcoal A black substance made from burnt wood. It can be made into sticks or pencils for drawing.

Creases Lines left in paper that has been folded or crumpled.

Festivals Special days or times during which people celebrate something.

Frame The border around a picture or window.

Head-dresses Decorated headgear sometimes worn during festivals.

Pastels Crayons made from coloured powders which are pressed and stuck together. The crayons look like coloured chalk.

Pattern Shapes and colours that are repeated.

Portrait A picture of a person or animal.

Powder A dry, floury type of substance like talcum powder or powder paints.

Sculptor An artist who makes his works of art (called sculptures) in solid materials like wood, metal or stone. You can usually walk around sculptures to see them from every side.

Self-portrait A portrait of oneself.

Texture The feel or look of a surface.

Tribal masks Tribes are groups of people who share the same way of life and beliefs. In some places, such as Africa and South America, they may make and wear masks for special days or activities.

Water-soluble colour pencils The colours from these pencils become watery when they are wet so that you can paint as well as draw with them.

Wax resist Using wax to keep areas free of paint.

Index

Acknowledgements

The publishers wish to thank the following for the use of photographs:
Visual Arts Library for M.C.Escher's *Three Worlds - 1955*, © 1955 M.C.Escher Foundation ® - Baarn - Holland, all rights reserved; Leonardo da Vinci's *Drawing for the Sforza Monument*, The Royal Collection; Edgar Degas' *Le Bain*, Private Collection; Charles White's *The Mother*, Hirshhorn Museum, Smithsonian; and Raoul Dufy's *Still Life with Fish and Fruit* © DACS 1994.
Reproduced by kind permission of the Henry Moore Foundation: *Second Shelter Sketchbook 1941, Sleeping Child Covered with Blanket* (front cover) © The Henry Moore Foundation; *Pink and Green Sleepers 1941* © The Henry Moore Foundation/Tate Gallery, London; *Mother and Child Scene 1978* © The Henry Moore Foundation.
Additional photographs reproduced by kind permission of Chris Fairclough Colour Library.

The publishers also wish to thank our models Anna and Jeremy, and our young artists Sue, Rebecca and Inigo.